LOVE STEALS US FROM LONELINESS

Gary Owen

LOVE STEALS US FROM LONELINESS

OBERON BOOKS
LONDON

First published in 2010 by Oberon Books Ltd
521 Caledonian Road, London N7 9RH
Tel: 020 7607 3637 / Fax: 020 7607 3629
e-mail: info@oberonbooks.com
www.oberonbooks.com

Gary Owen is hereby identified as author of this play in
accordance with section 77 of the Copyright, Designs and Patents
Act 1988. The author has asserted his moral rights.

A catalogue record for this book is available from the British
Library.

ISBN: 978-1-84943-054-8

Cover design by elfen.co.uk

Printed in Great Britain by CPI Antony Rowe, Chippenham.

Acknowledgements

My thanks to - John and Lucy and all at National Theatre Wales, for making me part of their inaugural season, despite my resistance. To Chris, Amy, Arwel, Elen and Sian and all at Sherman Cymru, for showing such faith in me over the last few years. To Paul Stockton, former Samaritans Regional Representative in Wales, for some conversations that shaped my thinking about this project. To Elin Phillips, Lynn Hunter and Rob Wilfort, for brilliantly showing me where I had gone wrong at the workshops. To Roger Burnell of Bridgend Youth Theatre and Guy O'Donnell of Bridgend Council's Culture Department, for letting me see how different today's teenagers are to my generation, and how similar. To Sarah Bland, Harley Smith, Rebecca John and Charles Smith, for contributing their stories. And thanks to Matw, Ben, Mathew, Andy W., Andrew P, Luke, Ruth, Grace, Lara, Anita, Andrea, Louise, Carolyn, Steph, Rhi, Rachel L., Rachel D., Welly, MacArthur, Bartle - thanks to all the Bridgend boys and girls. Even the rugby lads.

for Steffan

Love Steals Us From Loneliness was first commissioned and first produced by National Theatre Wales on October 7th, 2010, for its first performance at Hobos, Bridgend with the following cast:

BECKY, Remy Beasley
CATRIN, Kaite Elin-Salt
MAGS, Nia Roberts
SCOTT, Mark Sumner
MIKEY, Matthew Trevannion

Creative Team

Writer, Gary Owen
Director, John E McGrath
Co-designer, Neil Davies
Co-designer, Anna-Marie Hainsworth
Lighting Designer, Nigel Edwards
Sound Designer, Mike Beer
Emerging Director, Elise Davison
Casting Director, Sam Jones C.D.G
Production Manager, Nick Allsop
Stage Manager, Brenda Knight
Deputy Stage Manager, Sarah Thomas
Assistant Stage Manager, Charlotte Neville
Assistant Producer, Hannah Bevan
Set Construction, Matthew Thomas and Garath Gordon

Characters

CATRIN

SCOTT

MIKEY

MAGS

BECKY

Notes

Dialogue

A forward slash ('/') indicates an interruption point. A slash at the very start of a line is simply a reminder to the actor that they need to interrupt the preceding speaker.

A long dash ('–') indicates a speaker diverting into a new thought, or a new choice of words to express that thought, or a struggle (real or feigned) to find words.

A clause within two dashes is a parenthetical remark within the main thrust of the sentence.

Words in [square brackets] are unspoken, and included only to clarify the meaning of spoken text.

Music

In the musical sections, actors stay in character, but can acknowledge and respond directly to the audience. The characters are under no illusions about their musical skill or lack of same, but are utterly committed to their performance, no matter how embarrassing they may find it.

BEFORE

We're in a pub.

SCOTT enters. His dialogue here is a guide – the performer should feel free to improvise in this section.

SCOTT: Alright?

We're gonna kick things off with a little musical number. From me.

I know. Gulp.

Anyway I hope you enjoy. And - if you know the chorus, why not sing along?

Scott sings 'Please Don't Let Me Be Misunderstood', by the Animals.

And then we are –

– outside. Outside a church.

CATRIN is wearing a witch's costume – long black wig, green nose.

She is centre stage, squatted down, knickers round her ankles.

SCOTT: *(From off.)* Cat?

CATRIN swears under her breath, and SCOTT enters before she can get up.

He looks at her.

SCOTT: Are those your knickers?

CATRIN looks back at him.

CATRIN: These? No, I'm keeping them warm for a mate.

SCOTT: Having a piss, are you?

CATRIN: What else would I be doing in a graveyard?

SCOTT: Dunno. Might've popped in for a chat with your nan.

CATRIN: I'm not gonna piss in a graveyard where my nan is, am I?

How fucking disrespectful would that be?

SCOTT: You should've had a piss in the pub.

CATRIN offers her hand – SCOTT helps her up.

CATRIN: No, I couldn't, Scott. Because when you're stropping off, the whole point is, you strop off. And then you're gone.

SCOTT: Okay.

CATRIN: If you're gonna strop off, it's all - or it's nothing. You get me?

SCOTT: I do, definitely, get you.

CATRIN: So –

SCOTT: So that's a valuable lesson, thanks.

CATRIN: So I still need a waz.

SCOTT: Right, I'll –

He's moving off.

CATRIN: No, now you're here, do some good. Stand guard.

CATRIN retreats to find a likely spot. SCOTT stands guard. After a second -

CATRIN: Could you like... chat or something?

He turns round.

SCOTT: What?

CATRIN: Don't fuckin' look at me you perv...

He turns back, sharpish.

SCOTT: Sorry.

CATRIN: I'm just having trouble, cos you're gonna hear me?

SCOTT: When you... urinate?

CATRIN: You're gonna hear the little tinkle. So just... chat. You know how to chat, don't you Scott? You just open your mouth, and shit comes out?

SCOTT: Chat about what?

CATRIN: Anything. I'm not actually gonna be listening.

SCOTT: Okay. Well. *(Giving it a go.)* Nice night.

CATRIN: *(Focussed on other matters.)* Is it.

SCOTT: If you're into zombies. Which I am. Probably my favourite supernatural monster. I like the zombies played for comic effect in films like 'Zombieland' or 'Shaun of the Dead'.

CATRIN: Oh thank Christ for that...

CATRIN is urinating. SCOTT a bit unnerved by this.

SCOTT: Also I enjoy the old school killer zombies of the original George Romero movies and more recent work like '28 Days Later'. Course in '28 Days Later' the most terrifying monster of all was the army major as played by Christopher Eccleston, which is like saying, who is the real monster? The zombies or – society ?

CATRIN: Alright, enough.

SCOTT: Okay good –

CATRIN's shaking her tail, and then looking round for something to wipe herself with.
– cos I was running on fumes there. Not even fumes. I was running on the homeopathic / memory of fumes

CATRIN: / Have you got a tissue or something?

SCOTT: Got a hanky.

Under his lab coat, he's wearing a suit jacket, and in the pocket, a white handkerchief.

CATRIN: Like a proper one? Material?

SCOTT: Are you wanting it to wipe your... regions?

CATRIN: That or go pissy.

SCOTT: It's my dad's? Got his initials sewed in.

CATRIN: Right.
D'you like your dad?

SCOTT: Not really.

CATRIN: Well then...

SCOTT: Fair enough, yeah.

CATRIN's still squatting down on the ground, knickers round her ankles.

CATRIN: Are you gonna bring it me, or shall I use the Force?

SCOTT brings the hanky to her, taking care not to look down at CATRIN, then retreats.

CATRIN wipes herself down, then pulls up her knickers.

CATRIN: *(Of the hanky.)* I could wash it and give it back to you?

SCOTT: Nah, you're alright.

CATRIN: Tell your dad I said he's a ledge.

SCOTT: So you coming back in?

CATRIN: On a mission from Lee, are you?

SCOTT shrugs.

CATRIN: Didn't think to come himself?

SCOTT: He's respecting your space.

CATRIN: He is not respecting my space...

SCOTT: He is respecting your fucking space, actually. He can see by you stropping off you don't want to be around

14

him, so he's not coming after you – but at the same time, obviously yeah he is concerned about your fuckin' happiness and well-being. So Lee says to me, Scotty, pop along and mind she's alright.

CATRIN: And along you pop, Scotty dog.

SCOTT: Seems that way.

CATRIN: Abandoning your pint –

SCOTT: Was down to beige spit anyway.

CATRIN: Striding off into the night –

SCOTT: Bit of fresh air's nice.

CATRIN: What are you, his bitch?

SCOTT: No: his mate.
 (Thinking of it too late.) And I thought you were.

 CATRIN looks at him, not getting it.

SCOTT: His bitch.

CATRIN: [If] You'd've got that five seconds faster, it might actually've been funny.

SCOTT: So Lee says, are you coming back in or what. So are you, cos if you're not I can just fuck off.

CATRIN: *(Of his costume.)* What are you even supposed to be?

SCOTT: Frankenstein.

CATRIN: Frankenstein all stitched together body parts and the bolt through his neck? I'm not really seeing it.

SCOTT: What you've got in mind there is Frankenstein's monster. I am Professor Frankenstein, the doctor who created Frankenstein's monster.

CATRIN: And that's it - that's your dressing up? A white coat?

SCOTT: Well, what are you?

CATRIN: A sexy witch.

SCOTT: I know you're a sexy bitch, but what are you dressed as?

CATRIN: That's the second time in five minutes you've called me a bitch. Calm it down.

SCOTT: I did say sexy.

CATRIN: You just plonk a white coat on – and you think that's enough?
For Halloween?
In the Big End?
You fuckin' disgust me...

SCOTT: It's not just a white coat, I've got a suit underneath – jacket, pressed shirt, waistcoat, the lot.

CATRIN: What sort of doctor wears a suit? My doctor wears a fleece. Can see his nasty little chest hairs poking through the zip...

SCOTT: An olden days mad professor sort of doctor wears a suit. Watch any film.

CATRIN: When I first started going out, Halloween in town used to be mental. Now it's people like you –

SCOTT: People like me what?

CATRIN: Ruining it. Just not making the effort. You call that a costume? That's a disgrace.

SCOTT: If it wasn't for my disgrace you'd still have a pissy minge, so –

The second he says this, CATRIN is open-mouthed. He tries to carry on.
So just, so just be grateful...

He can't go on.

CATRIN: I can't believe you just talked about my minge.

SCOTT: Nor can I really.

CATRIN: My 'pissy minge'.

SCOTT: It was just words, I wasn't thinking about what they meant -

CATRIN: Yes you were, you sick bastard.

SCOTT: - I wasn't, like, visualising yellow drips / hanging off little hairs...

CATRIN: / Fuckin stop it right there!

SCOTT stops it.
What do you think Lee would say, if he heard you talking like that?

SCOTT: I think he'd do the serious voice, where it goes all low and quiet? And he'd give me the serious look, where it's like he doesn't blink, but obviously he must. And then he'd say, Scott, you're my pal, I love you like a fucking brother – but up with that, I will not put.
And I'd have to apologise to you and creep round the place like a buggered dog.

CATRIN: Yeah. I would bloody well think so.

SCOTT: And then after you'd gone we'd all have a fucking great laugh about it.

They look at each other.

SCOTT: Are you coming, back in the pub?

CATRIN: Yeah, alright.

SCOTT: Okay good.

SCOTT turns back toward the pub.

SCOTT: Actually though – look.

CATRIN: What?

SCOTT: The queue's fuckin' insane now. That's a forty-five minute maybe a full hour queue there.

CATRIN: Who the fuck would queue for the Roof?
Obviously, we do, but – seriously who the fuck would?

SCOTT: We could just... hang here.

CATRIN: Hang here?

SCOTT: Hang here for a bit the queue might go down and we can just... stroll in.

CATRIN: Hang here - in this graveyard?

SCOTT: Or queue for an hour with a bunch of townies and valley commandoes?

CATRIN: I do actually fuckin' hate townies and valley commandoes and cannot bear to be near them.

SCOTT: Who doesn't?

CATRIN: Okay. Hang in a graveyard. Happy Halloween.

CATRIN finds a place to settle. SCOTT does likewise.

CATRIN: I'd be fuckin' freezing, if I wasn't hammered out my skull.

SCOTT: Thank Christ you are.

CATRIN: Just what if I sober up?

SCOTT reaches into his briefcase, and pulls out a number of test tubes filled with brightly coloured liquid.

SCOTT: Which d'you want?

CATRIN: All of them?

SCOTT: But imagine that I wanted some too?

CATRIN: Red and green.

SCOTT: Strawberry and lime, excellent choice madam.

CATRIN: Hold on – these are like, test tubes: to go with your mad professor thing. You actually put some fuckin' effort in.

SCOTT: Nice that you noticed.

CATRIN: Just not so anyone can see. All anyone can see is a shit white coat.

SCOTT: Shit white? Is that a new shade they're doing in Dulux? Paint your walls the sensuous colour of a dried out dog turd...

CATRIN: Yeah, keep your effort tucked away secret and just be a smug cunt about it, why not.

They down the shots.

SCOTT: You know they're gonna ban these? Cos they're all curved there's no way to put them down –

CATRIN: You can totally put them down.

She puts down an empty tube on its side.

CATRIN: Ta-da!

SCOTT: But not without spilling the booze, you can't. You have to knock them back in one go.

CATRIN: And?

SCOTT: Encourages binge drinking.

CATRIN: It is not the curves of some test tube drives me to binge drink.

SCOTT: What does, then?

CATRIN: Your face. Plus what sort of twat sits nursing a shot of fruit-flavoured vodka? You chuck 'em down and get back to your pint. Or white wine spritzer.

She necks a shot.

CATRIN: Shit. I think there was actual fruit in that. I'm having a reaction. Oh God. Oh God...

SCOTT: Are you alright?

CATRIN: *(A few big breaths.)* I'm fine. And don't do that.

SCOTT looks at her – do what?

CATRIN: Don't ask me if I'm alright. Makes you look like a cock.

CATRIN sits, discontented.

CATRIN: D'you know what I hate? I hate how we can't even go out in our own town Friday Saturday cos of all the valley commandoes coming down and smashing the place up.
Like, last Saturday I saw this total fuckin' roider, tattooed head to foot, muscles like fuckin' boulders, moustache out of the Village People – doing a shit in the middle of Nolton Street.
And I said to her, love,
Do you act like that where you come from?

SCOTT: What she say?

CATRIN: She just made a series of grunts and animal noises, cos that's how they talk. And you know they only come here cos we got poles and they haven't.

SCOTT: Apparently they're all going home. Cos of the recession.

CATRIN: Not fuckin' – Poles as in plumbers. Poles as in dancing. Say you're getting a bit frisky at the end of the night, with us you hop up on the pole and bust your moves. But they got none of that up the valleys. They want to pole dance, they've gotta go out into the street and do it round a street lamp. And that always causes ructions cos half of them still worship electricity as a god so it's like desecrating a holy shrine. *(Off Scott's look.)*

What?

SCOTT: My mum's from the valleys.

CATRIN: And it's amazing, all the words she knows now.

SCOTT: Also – it's Friday tonight.

CATRIN: What d'you want, a prize?

SCOTT: You said, we can't go out Friday Saturday. But it is a Friday. And here we are – out.

CATRIN: And don't fuckin' do that.

SCOTT: Do what?

CATRIN: Don't – take things I've said, and then think about them, and then say things about the things I've said, and try and make me look a twat. Because if you do – that is the actions of a cunt.
Alright?

SCOTT: Alright.

CATRIN: Obviously we go out Friday Saturday. You got to go out Friday Saturday. It's gotta be done. But it's better Thursday Sunday, cos Thursday Sunday the trogs are all back in their holes. I'm not saying Thursday Sunday's any good – it's still shit cos of the townies.
But it's not quite as shit, is all.

SCOTT: What's the difference between a townie, and us?

CATRIN: I dunno, what is the difference between a townie and us?

SCOTT stares at her for a second.

SCOTT: Sorry no that wasn't a joke – I'm actually asking.

CATRIN: A townie is someone you see in town. Cos they're always out. In town.

SCOTT: We're always out in town.

CATRIN: But a townie lives in town. Like, closer to town than we do.

SCOTT: So the rule is, if you live closer to town than us, you're a townie...

CATRIN: Correct.

SCOTT: ...but if you live further away from town than us, you're a valley commando.

CATRIN: *(Like Aleksander the Meerkat.)* Simples.

SCOTT: Bit random, isn't it?

CATRIN: Random is where you pick something, like, at random. This is not that. This is a rule. A rule is the opposite of random.

SCOTT: So what if you moved, into town? Would you be a townie then?

CATRIN: You're doing it again.

SCOTT: What now?

CATRIN: Taking things I say, and then thinking about them, and then saying things about them.

SCOTT: I'm not allowed to think anything, or say anything, about anything you say?

CATRIN: It is the actions of a cunt, and no good can come of it.

SCOTT: Alright, so what if –

CATRIN sings over him, to shut him up.

CATRIN: *(To the tune of 'Twenty-Four Hours From Tulsa'.)* I was only twenty-four hours from Brackla, only one day away from your arms...

She stops singing.
You shut up now?

SCOTT: Looks like it.

She finishes her last shot, then raises the empty tube to SCOTT –

CATRIN: Cheers!

- and chucks it away.

SCOTT: I think you're supposed to say cheers before you drink?

CATRIN: And that's just me: a fuckin' rebel. Got anything else to drink? I bet you have.

SCOTT produces from his briefcase a silver coloured metal hipflask, and hands it to her.

As CATRIN swigs at the hip flask, SCOTT collects the tubes CATRIN has discarded, and puts them away in his briefcase.

CATRIN watches him do this without comment.

Then once SCOTT is settled again, she says
I was thinking about you, the other day. I was thinking – why doesn't Scott get himself a nice boyfriend?

SCOTT looks at her.
I mean properly nice. Because it's gonna be your first time, you don't want some townie cunt leaving you all traumatised. Like me and Lee, my first time I got like really panicky and my head was spinning and I was gonna chuck, and I thought if I try to stop him now, he's gonna go wild, he's just gonna you know hit me and it'll be like a rape thing and I can't hack that so I'm just gonna have to go through with it - and he stops.
He says, you alright?
I don't say nothing cos I'm like – on a knife edge.
He climbs off me, goes what's wrong?
Right then I gag. I clamp my hands over my mouth, not quite quick enough to stop the first wave of cider-vom spraying all over him.
And does he go wild? Does he fuck. He holds my hair, strokes my back while I'm chucking up into his mum's u-bend, and dabs the little strands of sick away from my

23

mouth with pink quilted toilet paper. All this still with a huge hard-on poking out his boxers.

And I'm riding the spasms of puke, thinking - please God, please God, please don't let me wee myself in front of him - because that might be a step too far on a first date.

But then in between retches, I turn, and I look into his eyes - still watering red from the acid in my sick - and I realise, it's alright.

Lee's a really really decent bloke.

He'll accept me for who I am.

And I just – relax.

SCOTT: You let the golden shower flow?

CATRIN: And he's fine with it. Puts my knickers and the bathroom mat in the wash, lends me a pair of his pants.

Even says I look cute in them.

He's that lovely.

And that's what you want, for your first time. A nice boy.

Don't go to Cardiff, cos all the Cardiff gays are hard-faced body fascist bitches, my uncle Teddy says.

And don't go with a rugby lad cos they're awful rough and they do get a bit self-hatey afterwards. Even with girls.

Find yourself a nice, floppy haired boy from say, St Brides, or Wick: someone you actually like, and not just sexually.

And you can have a kiss and a cuddle and he'll get the lube and warm it up in his hand so it isn't cold going on and then he'll, very gently, very lovingly, penetrate your bumhole with his throbbing bell end.

Sound appetising?

SCOTT: I'm not freaked out by the thought, if that's what you're trying to do.

CATRIN: I'm not trying to freak you out, lovely. I'm trying to help.

SCOTT: Just I happen not to be a poof.

CATRIN: This is the twenty-first century, Scott. It's actually a bit embarrassing to be that repressed. Fair enough in like the nineteen seventies when it was actually illegal, but every other cunt's a homo these days. Just fucking get over yourself.

SCOTT: Are you serious? Are you not fucking around? D'you seriously think I'm gay?

CATRIN: You know the rugby player Gareth Thomas, Scott?

SCOTT: We've never met, but I'm aware of his work.

CATRIN: You know he used to play a game, then go out, drink till he was full to burst, then run so hard and so long that he chucked up every last drop, and then he would start drinking again on a painfully emptied stomach?

SCOTT: I have heard anecdotage along those lines.

CATRIN: If a fighting 'n' fucking, gap-toothed, balding, ex-ginger like him can turn round and go, fair play lads, I'm a massive muscle-bound queen and have been the whole time, and all that happens is everyone goes, Alfie, we just love you all the more, you great big try-scoring gay bastard – then just maybe, an obvious nancy boy like yourself could man up long enough to stagger out of the closet and into the world of cock which eagerly awaits you.

SCOTT: But I'm not gay.

CATRIN: Scott: you're not a stomach-turner to look at, you're not a complete prick to be with – but you've never been with a girl, ever.

SCOTT: Went out with Becky last year.

CATRIN: As camouflage for your obvious gaysexuality.

SCOTT: I don't go out with anyone, so I'm gay. I go out with Becky - and I'm still gay?

CATRIN: You went out with her for six weeks. You did nothing. And I love her to bits but the girl's a fuckin whore.

SCOTT: We did... a lot.

CATRIN: Yeah you'd snog. Plenty of fumbling in the breastal area – but loads of poofs love tits, Christ knows I've clocked you gawping at my golden globes often enough – but beyond that, not a shag, not a suckoff, not a titwank, not a thighjob, not a footfrig – not even a swift five-finger fuck off the wrist.
(Off SCOTT's look.) We're girls, Scott. We talk.

SCOTT stops. And when he starts again, he's ready to make a confession.

SCOTT: Alright...

CATRIN: Thank God.

SCOTT: What it is,

CATRIN senses it's not the confession she's hoping for.

CATRIN: Please stop hiding from the truth.

SCOTT: When I was twelve, I found out I had a sexually-transmitted disease.

CATRIN: You're a virgin.

SCOTT: Except to my pillow, yes.

CATRIN: How does a person who's never had sex, get a sexually- / transmitted

SCOTT: / When you're a boy, in terms of cocks, you basically just see your own. You don't spend too much time looking at other boys' cocks -

CATRIN: Because, as a gay man, doing so would make you sexually excited

SCOTT: So you don't know what's normal, and what's not. And looking at my cock, I became convinced there was something wrong.

CATRIN: Is it bendy?

SCOTT: *(Beat.)* Yeah, a bit, but that's not it.

CATRIN: What then?

SCOTT: It doesn't matter.

CATRIN: Is it just microscopically small, but you thought it had actually died and rotted and shrivelled up to nothing?

SCOTT looks at her.

SCOTT: This is serious, alright? This was a serious fuckin'... trauma in my life. And I absolutely believed there was something wrong with me. I knew, if ever a girl did... fish little Scott out into the light, she would take one look, scream, vomit – probably onto little Scott – then scarper. So I just decided I would never go out with anyone, and would have to die, alone and a virgin.

CATRIN: That's so sad.

SCOTT: Thank you.

CATRIN: Sad as in pathetic, because then you did actually go out with Becky, so what's the story with that – didn't mind if she caught your cock rot?

SCOTT: Well that was... she came round to mine with a bottle of wine and she was looking – like not too much on show but everything quite tight, so you got a good idea what was on offer, and she said, I know you're married to your music,

CATRIN: - but have you got time for a mistress?

SCOTT: Sorry?

CATRIN: I was really proud of her coming up with that. Cos it was actually Rachel's dress she was wearing, the body con one, and we wondered should it be cans cos you're more of a lager drinker, but in the end we thought, no, bottle of wine – bit of class, like.

SCOTT looks at her.

CATRIN: We're girls, Scott. We talk, a lot.

SCOTT: Are you saying, every interaction I've ever had with a girl, her and her mates have planned it out before in exhausting detail?

CATRIN: No.

SCOTT: Are you lying?

CATRIN: ...Possibly.

SCOTT: And you're going to talk about this, aren't you? About me thinking I had VD?

CATRIN: Not necessarily –

SCOTT: Which I haven't, by the way.

CATRIN: - and that's good to hear. But no, actually; a confidence like this should be respected.

SCOTT: Thank Christ for that.

CATRIN: But then – there will no doubt come a time, some point in the future: an evening when drink has been taken, and – I might not be able to resist. So let's say – I'll do my best but yeah, probably three to six weeks and every fucker in town will know.

SCOTT: Brilliant, cheers.

CATRIN: So how come you haven't got VD now then?

SCOTT: Becky's round mine, she's brought this magazine and I'm taking a crafty look, cos it's a magazine for the modern woman, and most of it is telling modern woman she needs to work hard at being a really filthy shag or modern man will piss off and find himself someone that bit sluttier, and obviously I find that material all quite... educational. And there's this article about cocks. Cock do's and don'ts, cock varieties and uses, cock features, cock foibles. And reading it, I realise – the thing I thought was weird and wrong is

actually perfectly normal. There is nothing at all wrong with little Scott.

CATRIN: And what did Becky say?

SCOTT: Nothing. I didn't tell her about my imaginary VD.

CATRIN: No, course not. *(Off SCOTT's look.)* Cos if you had, she'd've told me.

SCOTT: Well, of course…

CATRIN: So how come you didn't do it with her, once you knew you weren't foul in the crotch?

SCOTT shrugs.

CATRIN: Christ, I would, just to try it out.

SCOTT: The thing with Becky was
I went out with her because
I knew I could tell her no.
Like if she wanted to do it
I could tell her no, and it wouldn't be a problem.
If she liked me, that was nice,
If she was pissed off with me, that was alright too.
And I had to go out with someone like that: someone I could say no to.
Because I was contaminated.
But then I realised I was alright, and I could go out with anyone.
Like someone I properly liked.
So I dumped her.

CATRIN: When you say, 'then', you mean…

SCOTT: That day.

CATRIN: Oh my God.

SCOTT: It's like pulling off a plaster. Do it quick, before you think about it.

CATRIN: All men are fucking psychopaths, I swear to Christ.

SCOTT: *(Beat.)* How's that, sorry?

CATRIN: You're on about dumping Becky –

SCOTT: Dumping. Not killing and dismembering.

CATRIN: You're talking about dumping my friend, like it was nothing.

SCOTT: Not nothing, but – you know.

CATRIN: Was she upset?

SCOTT: Yeah, course.

CATRIN: Did you give a toss?

SCOTT: Yeah, but – you go out with people, some point you're gonna get dumped.

CATRIN: Oh my God – have you ever thought of becoming a relationship counsellor? Or maybe like a religious leader? Cos that is so much fuckin' insight you've changed the way I'm gonna look at the world forever.

SCOTT: I'm saying, it's gonna happen. Relationships end. Which means someone's got to end them.

CATRIN: Alright one time, me and Lee were having an argument –

SCOTT: 'Bout what?

CATRIN: And I said it was over and

SCOTT: You finished with him?

CATRIN: I said I was finishing with him, cos I was pissed off – and he folded up. Like all the bones had come out of him. He was rolling on his back. Grabbing at his guts like it actually, physically hurt. And I thought – that is what love is.

SCOTT: Is it?

CATRIN: I thought this guy properly loves me.
 And I had no idea,
 Till I saw him choking too much to even cry.

SCOTT: Fucking hell.

CATRIN: Breathe a word and I will slice you up, swear to God.

 SCOTT doesn't say anything.

CATRIN: Lee loves me so much, he literally can't go on
 without me.
 And that's why he sent you after me. He gets scared when
 I get angry, cos –

SCOTT: - cos you might finish it.

CATRIN: Just in my anger, like. Not for real. So when I lose
 it, he runs off. Or I do. And he never comes after me, he
 doesn't dare. But he sends his poofpal to look after me, cos
 he's that much of a sweetheart.

 Pause.

SCOTT: Didn't know you two'd ever broken up.

CATRIN: We didn't.

SCOTT: But for a bit

CATRIN: For like ten seconds

SCOTT: I never thought you two argued even, you always
 seem so / just happy

CATRIN: / Which shows what a twat you are. Everyone argues.

SCOTT: I wouldn't know.

CATRIN: It's part of a healthy relationship.

SCOTT: Never seemed healthy when my mum and dad rowed.

CATRIN: There's healthy ways and unhealthy ways.

SCOTT: And you and Lee argue in healthy ways.

CATRIN: Yup.

SCOTT: How d'you know the difference?

CATRIN: Well like your dad used to smack your mum about?

SCOTT: *(Beat.)* Yes he did.

CATRIN: That's pretty fucking unhealthy.

Pause.

SCOTT: So… you and Lee argue a lot then?

CATRIN: No.

SCOTT: But every now and again.

CATRIN: Yeah.

SCOTT: Like how much?

CATRIN: Like a normal amount.

SCOTT: Every week, every day, every hour…

CATRIN: It doesn't even matter how much. They've done research, and there's a ratio. For every act of anger, five acts of kindness. And they have proved, it doesn't matter how many actual fights you have; so long as you make up with five times as many acts of kindness, you're alright.

SCOTT: Where'd you read that, on the web?

CATRIN: On the web and in an actual book by an actual psychologist, actually. It's like a known issue.

SCOTT: So these psychologists say, you could be fighting ten times a day, but so long as you're nice to each other fifty times a day, it doesn't matter.

CATRIN: It actually makes the relationship stronger, if anything.

SCOTT: And was that quite reassuring, to find that out?

CATRIN: Well yeah.

SCOTT: You and Lee argue a lot then, do you?

She doesn't answer immediately.

CATRIN: It's a very passionate relationship. We fight. And then we're nice to each other. Very, very nice, if you get me.

SCOTT: Yeah, I get you.

CATRIN: I wouldn't think you do. Virgin.

SCOTT: So, literally, the two of you fight and then you make sure you do five nice things to make up for it?

CATRIN: Yeah.

SCOTT: How does that work? Say you take him upstairs for a bit of bedroom action, and he gets a bit of hand shandy, a blowie and then a shag – is that three nice things, or one?

She looks at him.

SCOTT: I'm serious. In the relationship stakes I'm a total newb and this seems like a really valuable opportunity to learn from your experience.

CATRIN: Alright. In that situation, I suppose it depends on, does he come? From the handjob, and from the blowjob and from the shag?

SCOTT: No I'm thinking it's all part of one...

CATRIN: Session?

SCOTT: Yeah.

CATRIN: Well then it's one. I'd count that as one nice thing.

SCOTT: So the orgasm is the key.

CATRIN: Lee seems to think so.

SCOTT: And then what, to get you up to five?

CATRIN: Maybe go out get him chips and curry sauce, that'd be one thing.

Then clean it up so he doesn't have to, that'd be another. Then whatever. Like if he wants to watch a film, watch what he wants not what I want.

And then -

SCOTT: Maybe another shag?

CATRIN: If he's up for it.

SCOTT: And it's like a rule? And you're there, following the rule the whole time, counting up and thinking of new nice things to do?

CATRIN: Yeah.

SCOTT: And what if you fight again, before you've finished your five nice things?

CATRIN: Then you add the next five on.

SCOTT: What – you keep a running total?

CATRIN: You have to.

SCOTT: And what's the total now?

CATRIN: Well, we had a rough patch last week, so – I owe him seventeen. Plus another five cos of this tonight.

SCOTT: Fucking hell...

CATRIN: You gotta work at things, Scott, when it's a proper relationship. 'Course you have.

SCOTT: And then - how will that work when Lee's gone away to uni? Like if you have a fight and then you're not seeing him. Send him some dirty texts? That's gonna get old.

CATRIN: Obviously that'll be different. Cos you don't know what's gonna happen. You go off to uni, you're doing different things, meeting different people. You're gonna change.

SCOTT: Are you?

CATRIN: I mean he is. He's the one who's going.

SCOTT: And then -

CATRIN: And then what?

SCOTT: And then - he might meet someone else.

CATRIN: It could happen.

SCOTT: And you -

CATRIN: I'd be gutted obviously.

SCOTT: Do you think it will happen?

CATRIN: You don't know, do you.

SCOTT: You do a bit. Like if you look at other people. When they go off to uni, usually -

CATRIN: Yeah, I know, they split up.

SCOTT: Yeah.

CATRIN: And I'm ready for that. If it happens.

SCOTT: Well it will happen. Happens to everybody. I can't think of anyone who's stayed together. Think of like, everyone's brothers and sisters of everyone you know... (*He stops.*) Never mind, maybe you'll be the first.

CATRIN: Maybe.

SCOTT: I think you might, actually.

CATRIN: So do I.

SCOTT: Tell you what, it is weird, though –

He leaves it hanging till he has CATRIN's full attention.

CATRIN: What?

SCOTT: You just now, talking about when you finished with Lee – and he had basically a fucking mental breakdown

right in front of you. And then you talking about Lee going off to uni and finding someone else –

CATRIN: And I said I'd be gutted.

SCOTT: Yeah you did. You said that. You said it – very calm, very cool. The thought didn't seem to bother you too much.

CATRIN: News just fuckin' in Scott: there's a difference between things actually happening in real life, and thoughts. Obviously if it really happened I'd be in bits.

SCOTT: Obviously. *(Beat.)* Be a bit of a relief, though. Not having to keep a running total of all the nice things you owe him...

CATRIN: All I care about, is Lee being happy, and you know if that turned out to be with someone else then – I'd have to deal with it.

SCOTT: You are saying some very complicated things about your feelings for my best friend.

CATRIN: Feelings are complicated.

SCOTT: I think Lee's feelings about you are very simple.

Stand off.

And then SCOTT makes to leave.

CATRIN: Where you off?

SCOTT: Lee loves you.
He thinks you love him. In a very uncomplicated way.
And if you don't, then – he should know that. So I'm gonna tell him.

CATRIN: What fucking business of it is yours?

SCOTT: His mate. And it's mates before muff, Catrin, every time.

He's still going.

CATRIN: Alright alright alright.
　　Let's cool it down, shall we?

SCOTT: I'm about as cool as I need to be, thanks.

CATRIN: Will you just listen to me for one second?

SCOTT: I'm listening.

CATRIN: Alright.
　　Alright.
　　Most of the time I feel like I love him, like
　　If something bad happened to him I'd die.
　　And then sometimes –

SCOTT: Sometimes you hate the fucker?

CATRIN: Cos who even knows?
　　How d'you actually tell, if you love someone or not –

SCOTT: Well, that's what they say, in all the films:
　　When it's true love, you'll – just not be sure either way.

CATRIN: That is not what they say in all the films.

SCOTT: What d'they say then?

CATRIN: They say
　　When it's love,
　　You'll know.

SCOTT: Yeah they do. Yeah.

CATRIN: Well, fuck them. Fuck films.
　　Lee is so lovely. He's been so lovely to me. And I'm gonna
　　stay with him and give him everything I can and then
　　when he goes off and he meets someone so much better
　　than me, then –

SCOTT: Then –

CATRIN: Then alright. Then fine. Then I'll cry – and I will cry,
　　cos it'll fuckin' hurt – but I'll let him go.

SCOTT: And you'll be glad. A little bit.

CATRIN: I'll be glad he's happy, yeah.

They look at each other.

CATRIN: And he could have a year with me, being happy
enough, and then find someone better.
Or you can go tell him all this now, and break his heart.
And for what? For nothing. Just to be a cunt.

SCOTT: Alright.

CATRIN: Alright?

SCOTT: That makes sense.
I'll keep it shut.

CATRIN: Promise?

SCOTT: Oh yeah for definite.

A moment; they're looking at each other.

CATRIN: What?

SCOTT: I love how everyone thinks Lee's this fucking angel.

CATRIN: He's not an angel. He's just nicer than... you, for
instance.

SCOTT: You remember the first weekend you got off with him?
That beach party, down Rest Bay. We were – fourteen?

CATRIN: That was so not the first time I got off with him...

SCOTT: Well it was the first time I'd been to a beach party.
First time I'd been to the beach since I was little, with my
mum.
I turned up in like my jeans, and then just my trunks.
Everyone else had shorts and t-shirts, me there in my itsy-
bitsy Speedos, feeling a teeny-weeny bit...

CATRIN: Exposed. Cos someone might see your rotten little
willy?

SCOTT: We all got pissed, and you got off with Lee, and everyone ran off to play frisbee. But I couldn't get up cos I was sitting there, with like my t-shirt on my lap, to cover up... my embarrassment.

CATRIN: I don't remember that.

SCOTT: You were pissed.

CATRIN: Or your 'embarrassment' wasn't worth remembering...

SCOTT: You'd come in cut off jeans and a shirt over your swimsuit, and Lee'd worked you out of your shirt and every now and again he'd risk just skimming his hand over your tit, never really touching down on it – and then he slid one of the straps down your shoulder.
Your right shoulder, as I was looking at you.

CATRIN: Fourteen, and my tit hanging out on Rest Bay. That is so shaming.

SCOTT: No. It was just – your bare shoulder. With girls, just how they dress you're gonna see a bit of leg, you're gonna see a good few inches of cleavage, you're gonna see some belly now and again. You can see all that any fuckin' street any night of the week. But a bare shoulder. You only see that when you've slipped a girl's strap down. Or you've pulled her top off over her head. You only see bare shoulder when you're undressing her. And she's letting you.

CATRIN: Bollocks you do. Halter top, boob tube, any kind of strapless dress, you see a bare shoulder...

SCOTT: And all the time I'd been trying not to look at the two of you but I just could not stop staring at your shoulder and – you looked up. And looked at me. And you said -

CATRIN: Don't remember any of this.

SCOTT: You said, "I think Scott wants some. Well tough luck, Scotty dog, cos you're never gonna get it."

And then Lee hauled you up. You were staggering a bit but he led you to this little cranny in the rocks where the two of you could lie down and no-one could see you.

You were in there for about ten minutes. And then you came out. You and the girls decided you wanted to go to the water for a swim. And once you were all just dots in the sea splashing about, Lee leaned over, and he stuck his finger under Damian's nose, and he said, smell that.

And he went round all the boys, making them smell his finger.

CATRIN: Did you? Smell it.

SCOTT: No.

CATRIN looks at him.

CATRIN: Yeah you did.

SCOTT: Alright then. Yeah I did.

CATRIN: What did it smell of?

SCOTT: *(Not immediately.)* Nothing.

CATRIN: Yeah, cos I never let him finger me on the beach. There were fuckin' little kids everywhere.

SCOTT: Thought you didn't remember.

CATRIN: I was just as bad, boasting to the girls about pulling a boy from the year above – so what's the difference? No, I wouldn't've gone round shoving my hand up the girls' noses going 'Way-hey, get a load of the precum on that!' – but that's cos women are innately much more fucking dignified.

SCOTT. And you go on how you finished with him but then he was bawling...

CATRIN: Yeah...

SCOTT: You know they discovered something called feminism like fifty years ago and it meant girls could do like bloke

stuff? And you're so fucking smug cos you think you rule now, it never occurs to you boys might've learned a trick or two.

CATRIN: The fuck you on about?

SCOTT: You try to dump him – he turns on the waterworks. Oldest trick in the book.

CATRIN: No way.

SCOTT: When he starts to go, does he like – turn away?
Cos he's so ashamed at how vulnerable you make him?
And does he cover his face with his hands, and you pull his hands away – you find you can, even those he's stronger than you at that moment he is so heart-breakingly weak that you can overpower him and expose -
Yes!
The tears.
The tears glistening in his never-more-beautiful eyes.

(A beat: and he switches into Star Trek voices.)
Captain! Imminent dumping on the starboard bow!
Deploy the sob shield, Ensign!
Sob shield deployed, sir. Dumping neutralised.

(Back to his voice.)
We're 21st century boys, Catrin. We talk.
And I didn't come out here like Lee's fucking bitch.

CATRIN: What then?

SCOTT: I saw you strop off in a right state and I thought, someone best go see she's alright, and I looked at Lee expecting him to shift... he just fucking sat there.

CATRIN: You came after me off your own back?

SCOTT nods.

CATRIN: That is really sweet. That is so sweet, / Scott.

SCOTT: / But it's fine.

41

He'll go off to uni, you'll just… drift, and it'll all wrap itself
up without any nastiness.

Except

Lee's going to ask you

To marry him.

CATRIN: What?

SCOTT: Not yet. Second his student loan comes in though
– he'll be down Elizabeth Duke for some tasteful yet
affordable sparkle.

The boy you love, wants to marry you.

This must be the happiest day of your life.

She doesn't answer.

SCOTT: Because it's not fair, what you're doing.

It's not fair on Lee you're stringing him along.

It's not fair on you, you're with someone you don't love.

And it's not fair on me.

CATRIN: You?

SCOTT holds out his arm, his palm flat, parallel to the ground.

SCOTT: See that?

CATRIN: Your hand.

SCOTT: And what's it doing?

CATRIN: Just sort of – hovering there.

SCOTT: It's shaking.

CATRIN: I can't see it.

SCOTT: Well it is. A bit. And it is shaking because
Every muscle in my body wants to come over there
Grab you, pull you to the ground
And just fucking devour you, right here, right now.

CATRIN: Oh.

SCOTT: Because I love you, Catrin.

CATRIN: Oh again.

SCOTT: And that's enough, actually.

That's enough to have said those words out loud, looking into your fucking amazing eyes, cos Christ knows I've said them in my head enough times.

Actually I'm lying. It's not enough.

I want you. I want all of you. I want you now and I want you forever.

Actually – that sounded shit – 'I want you now, I want you forever'. That's because it's a line I came up with God knows how many years ago and imagined saying it to you, one day, but now I do it's fucking lame.

What I'm saying is – the reason why I've never been out with anyone, it's not cos I'm diseased, it's not cos I'm a poof. It's cos I've always wanted you. No-one else is worth the effort.

And I would never let you run off into the night because I was scared you were gonna dump me. I would always be there, making sure you're alright.

And I don't care about getting my heart broken because I would take a day an hour one fucking second with you even if it meant being heart-broken the rest of my life.

And I know I'm not good enough for you because you're so / amazing

CATRIN: / I'm not amazing...

SCOTT: You are, you are amazing.

CATRIN: How am I amazing?

SCOTT: *(Struggles for a bit, then.)* I don't know where to start. I mean look at you.

CATRIN: What about me?

SCOTT: *(Again, struggles: and then.)* You're a sexy witch.

You're magic. And gorgeous. And amazing. And maybe people in this fucking stupid town don't get it but I do, I see how amazing you are and I just hope whatever happens we stay friends always, because I wanna be around to see what fantastic things you're gonna do with your life. And like I say I know I'm not good enough for you but being with you would make me be better, I'd be a better man, for you, every fucking day.

I love you.

I love you Catrin.

And it is so – amazing, to finally say it.

AFTER

Karaoke music starts.

MIKEY: Oi Cat.
Cat you're on.

CATRIN: Now?

MIKEY: Or never. Come on, get over here.

CATRIN sings a couple of verses of 'You Always Hurt the One You Love'.

She gets a little way into it, and then MAGS starts to talk to the audience.

MAGS: Look at you.
Look at you all.

BECKY: Mum.

MAGS: Look at your faces.

BECKY: She gets like this sometimes.
After a drink.
Not a lot you can do. Just have to ride it out.

MAGS: You're waiting for things to go back to normal.

MIKEY: Who's next? Mags? D'you wanna go?

BECKY: Mum, calm it down.

MIKEY: Mags, you'll do a song, everyone else has...

MAGS: Normal's gone now. Wave it goodbye.
Come on, wave with me. Let's all wave good-bye to normal.
Bye-bye! Bye-bye!
Why aren't you joining in?

BECKY: Did it bring us closer?

No. Then yes for a bit.

Then no no no, for a long time.

Then yes. Eventually.

MAGS: The first thing they do when something like this happens –

They look at the family.

What were the... circumstances.

Alright then.

SCOTT: I know it's gonna be horrible. I hope it's gonna be worth it. Love, Scott kiss kiss.

MAGS: People would say to me sometimes – Mags, how come you stuck that husband of yours so long's you did?

I'll say, well, he was funny. Always telling jokes. Always raising a smile.

People say, what kind of jokes, Mags?

Well... he'd say, I call my wife treasure – cos she looks like something you dug up.

He'd say, I call my wife the queen – cos she looks like a bloke in drag.

He'd say I call my wife pumpkin – cos I'd like to take the top of her head off, scoop out the inside for soup, then stab her in the face where her eyes should be.

And I would fall for a silver tongue, when I was younger.

BECKY: Message one of forty five. Home in twenty. Can you put the oven on? Maybe chuck some burgers in?

MAGS: People say, do they know, Mags? Your kids.

Do they know what a bastard he was?

Why don't you tell 'em? You should tell them. They got a right to know.

Not a chance.

Those kids don't get much from me but what I can, I give them.

BECKY: We've got nothing in.

LOVE STEALS US FROM LONELINESS

MAGS: And what I give them is nothing,
 Compared to what they give me.

BECKY: We got nothing in, mum. For tea.

MAGS: That was his favourite thing, after he passed his test.
 He could bomb down the beach in the dead of night
 Walk in the waves, looking up at the deep dark sky
 And the cold light of all those stars.
 Absolutely loved it.

SCOTT: Just call if you need me.

MAGS: He'd always go on about how much blacker the sky
 was
 How much brighter the stars,
 Just those couple of miles out of town.

BECKY: We're at Tuskers till two, the Roof till four,
 Then we hold out at the York till six.
 Those last couple of hours I can't say too much about,
 except
 I spent them parked on the lap of a tearful fortysomething,
 Who kept the drink coming while his ring and middle and
 index
 Went about the old up and under: under the skirt,
 Up the thigh, till his nail scratched knicker and I leaned in
 and said
 What was your daughter's name again?
 Cos maybe I know her?
 Like from school?

MAGS: It's happening again.
 It's happening, now.

SCOTT: Let me know how it went.

CATRIN: Lee ran, jumped in his mini,
 And he was gone.
 And I am never gonna be free of this.

BECKY: I was walking home.

> I these flip-flops on, cos
>
> The heel'd come off my shoe.
>
> I remember the step I took wrong, off the kerb outside the Roof
>
> And this crack, and my foot twisting and giving way
>
> And for a second I thought fuck, I've broken my fucking ankle or something
>
> But then I saw my ankle was alright, it was my shoes that were fucked
>
> And even though the shoes were basically my favourites
>
> I didn't really mind, cos I was just super-relieved I hadn't broken my ankle.
>
> I even chucked the shoes in a bin –
>
> Like just to show how totally alright I was about it?

SCOTT: I love you.

> I can't believe I get to write that.

BECKY: Later I thought, that was fuckin' stupid cos you can get a heel fixed.

> And later again someone said to me aw Bex look your fuckin' foot's bleedin'.
>
> And it was, from like glass or something somewhere.
>
> And I looked and there was this trail of little red blotches on the floor, following me around,
>
> Showing me where I'd been.

MAGS: Here's what really kills me.

> Here's – one of the things that kills me.
>
> All that night I'd just been fannying about worrying the electric was gonna go off.
>
> I'd had twenty on a token and put it through but
>
> The bastard didn't work. The bloke in the garage said
>
> Can't help you love, you've put it through, I can see the mark.

All I could do was buy another token and hope that one worked.

All I needed for that... was money.

BECKY: Message six of forty-five. Yes, course I will, you've only told me like a million times.

MAGS: I'd been through the house like a robber and turned up maybe eighty pence in change

But then I found a scratchcard Lee'd given me Mother's Day

And it only went and turned out to be a winner.

But then there's nowhere open I can collect on a scratchcard,

Then get back to the garage to buy another electric token before it shuts at ten.

So I'm into the Bells and asking Huw not for a lend but

A swap, cos a winning scratchcard is basically money in the hand

But Huw-

BECKY: Mum?

SCOTT: Cat will you just give me a call?

BECKY: Mum.

There's nothing in the house, shall I go for chips?

MAGS: Yeah, alright, go on.

BECKY: So do you want a piece of fish, with yours?

MAGS: I'm telling you, now, about him.

And then it all comes over me: the memory of him.

How can it be, I remember him

Even when I'm remembering him?

BECKY: Or will just chips be enough?

MAGS: I hear the couple over the road,

Ken and Jan. Lovely, both of them.

Ken's a bit older. Got cancer in the throat and
They're just letting it go, so he can have
What time he's got, you know.
I hear Jan helping him into the car, and then
She's saying – are you sure you feel like going?
It's everywhere. It's too much.

BECKY: Mum?

MAGS: Bex. Love. Get chips, don't get chips,
But what the fuck you asking me for?

BECKY: Cos you know the street pastors?
If you've been out here, you know 'em.
I'd always thought the street pastors were
Just a bunch of cunts really. Cos
They're there, in their little street pastor gang
With their little street pastor anoraks
With 'STREET PASTOR' written on them.
Like they're so fuckin' pleased with themselves
And they just make you feel – you know
They're looking at you and they just think
You're a stupid drunk slag, but then
I went up to them, gave it some chat, I said
I broke my shoes and then I chucked 'em in the bin and
now my foot's bleedin.
And they gave me these flip-flops?
For nothing like, just handed them over.
And I was walking home with
The flip-flips all squishy under my feet and thinking
They're alright, really, the street pastors.
I mean, it's fuckin' sad that people have got nothing better
to do
Than tramp round town on a Saturday, not even getting
drunk but
I thought they were cunts, and they're not.
Fair play, I was wrong about that.

And then a police car went by me.
And then a ambulance.
And I thought –
Not a thing.
Cos when d'you ever have a night out here,
And not see police, or ambulance?
Fuckin' never, is when.

SCOTT: Cat will you just give me a call cos
 Someone said something a bit... weird.

BECKY: I saw the police,
 And the ambulance,
 That were going to him.
 And I didn't think a thing:
 I was pissed.

MAGS: I'm in the Bells with a winner in my hand and this
 baldy fucker at the bar says,
 I'll have the scratchcard off you.
 And he holds out a fiver.
 I say, three the same on a scratchcard's a tenner.
 He says, I know. But a fiver's all I'm offering love,
 Take it or get to fuck.
 And I take it.
 And I run,
 So my son can bring his girl home to a house with the
 lights still on
 I get to the garage at nine fifty seven:
 The bastard place is closed anyway.
 And this is it, starting to happen now –
 I come awake somewhere round half four
 When I hear Lee start his mini and the headlights flick full
 on
 And everything in the lounge is white light or deep shadow
 Then Lee pulls away, and dark takes the room again,

And out the window I see Catrin, standing on the
pavement,
Crying.
And I think, good for you, son.
I know.

BECKY: I put a couple of painkillers to fizz in a pint of water
Took them down in six or seven burpy gulps,
Sat still and propped upright to try and keep them all
down and
And I must've fell asleep like that.
When I woke I got my phone hoping for a message
From this boy I snogged between Tuskers and the Roof
and -
And there was.
A message.
But from my mum.
It said
Lee's dead.
I thought
Fuckin' brilliant.
Cos I thought like it meant
He'd done something and mum
Was gonna finally, totally kill him this time.

SCOTT: Okay, panic over. He's alright.

MAGS: He came off in a lane, on the way to Monknash.
Wasn't wearing a seatbelt.
Was thrown clear of the vehicle.
Apparently, a taxi came past only minutes after. But
Apparently, the driver didn't see Lee and reported
A car, crashed and abandoned.
The despatcher assigned it a low priority.
And it being a Saturday, and the emergency services
Tied up dealing with twenty thousand drunk bastards in
town.

It took the police two hours to get round to checking it out.
Once they were actually in attendance at the scene
Apparently it took them thirty or so seconds
To find my son.
One officer began to administer emergency first aid
While her partner radioed for an ambulance.
They say he was probably unconscious, those two hours.
They say it like that should be a comfort.
Better he be unconscious, than be lying there,
Hurt and alone.

SCOTT: He's at casualty in the Princess of Wales, he's gonna be
alright. But please call.
I don't want anything I just wanna look after you.

MAGS: And that night.
That last night.
Those last hours and minutes while my son was here –
All that fuss. About the fucking electric.

BECKY: Half asleep I was thinking –
Say something really happened,
No way'd you just text, Lee's dead.
You'd never just – say the words, and say nothing else.
You'd say something more:
To try and make it better?

MAGS: And that bloody taxi driver.
If he'd just got out his car.
If he'd just looked.

SCOTT: Oh God.

BECKY: But what?

MAGS: I hope he feels like shit.
Not being funny but, I mean that.

BECKY: What words could you say?

SCOTT: Cat I just heard.

MAGS: And if I can run about like a nutter cos of the electric,
Why couldn't I run out, throw myself in front of the car?
Grab a knife from the kitchen and slash his tyres?
Loads of mad things I could've done
That would've saved him.

BECKY: Message nineteen of forty-five. If you're in Boots, can you get me some deodorant? Ran out today and my pits are hanging.

CATRIN: I went to my room like a naughty child.
My mum brought me cream of tomato soup, scrambled eggs and toast
– food for when you're sick –
She didn't come in.
Just knocked on my door, left the plates on the landing.
After three days I turned on my phone and
It was full.
More messages than it could take.
All of them saying –

SCOTT: I wanna be here.
I am here. I'm here for you.
Just call. Just text. Just –
I'm here.

CATRIN: – just saying sweet, and useless things.

BECKY: I remember staring at my ankle once –
About ten years of age, this was.
The veins there are really close,
Just below the ankle bone.
And sometimes, you can see your pulse.
Have a look. Come on, have a look now.
See it?
That bump, bump, bumping, in the skin.

It's barely anything.

It's you.

Because if that stops.

Then you will too.

And I couldn't get my head around it.

Everything I think and everything I say

And everything I do and everything I'll wish I'd done

All gets wiped out

If that flicker under the skin ever stops.

It's fuckin' ridiculous.

I remember the first time I did it the bloke saying

It feels soooo fucking good being inside you.

And first I was thinking – alright mate, you got what you want

So give the cheesy chat a rest, why not?

But then thinking –

Hold on, you're not.

You're not inside me.

You're just in my body.

MAGS: The pinging stops,

 They switch off the machines

 You're waiting

 For him to cough

 For his eyes to open

 For the nurses to call the doctors and

 The doctors to start bang bang banging on his chest.

 You're looking ahead to the time

 When you can cast your mind back and say

 That was a close one.

 Son, you had me bloody worried then.

 These things you're waiting for, don't happen.

 A nurse brings you tea and they get on

 With tidying up, tidying round you,

 Tidying away.

And you wonder what it is that's wrong
What it is that's bothering you and
It's the clock. Ticking on the wall,
When it should have stopped.
And every tick is taking you further away
From the time when your son was alive.

BECKY: Message twenty-two of forty-five. I know. I'm sorry.

CATRIN: He didn't tell.
I saw his mum and

MAGS: He said, you and him'd had a fight.
And it was all his fault,
And he wanted to see you, so the two of you could make it up.

SCOTT: He was gonna use it.
Drips in his arm and machines pinging away his heart's beat –
He was planning how he'd guilt you into going back out with him.
And I would never say that. If things were normal, if this was a normal conversation.
But it's true. I'm sorry.
I'm not sorry, actually.

MAGS: He softened me. For definite.
Because I would never say words like poo, or do-doos.
Thought that was pathetic: a grown-up saying 'poo'.
I would call a shit a shit, never a 'number two'.
But then he was born and I could never say
Look, he's still got shit in the little fat folds of his thighs,
Best give him another wipe.
Couldn't do it.

BECKY: Mum, shall I go and get chips?

CATRIN: He was forgiving me. Was he?

He was letting me off. Was he?

That's why he didn't tell everyone

What a fucking bitch I'd been.

Wasn't it?

SCOTT: Or – and I'm just putting this forward as another way
of thinking about things

Say he'd ploughed into a gang of kids walking home from
town?

Say he killed one of them – we'd've been thinking, selfish
cunt.

Well – I'm thinking it now.

Letting you off? Like fuck.

MAGS: Has he still got poo-poo on his little legs? Aw, poor
little sweetheart...

SCOTT: It wasn't up to him to let you off. Selfish cunt.

MAGS: Mummy clean it up for you. There we are...

CATRIN: And on the third day I got up

And found Scott.

And we got drunk.

Obviously.

SCOTT: Shall we then?

CATRIN: D'you wanna?

SCOTT: I'm just – you know. Is this the... moment?

CATRIN: What else is it the moment for, Scott?

SCOTT: I don't – what d'you mean? We could do anything.
Drink more, watch a film...

CATRIN: Watch a fucking film? Will I – sit and watch a film?
D'you fucking think?

SCOTT: I mean, we can do whatever you want.

CATRIN: I can't do what I want.

SCOTT: What do you want, that you can't do?

CATRIN: I want to make it not have happened.

MAGS: In the olden days they used to have loads of kids.

BECKY: She just went to pieces.
I mean: of course.

MAGS: I always thought they had loads of kids cos in the olden days
Loads of kids died, and you wanted to have a few left
To look after you when you were getting on.
But that's not it.
They had loads of kids in the olden days cos, when one dies
It's only the others keep you going.

BECKY: Shall I get you some chips, if I'm going?

CATRIN: I might need... a bit of space, for / a bit

SCOTT: / Is that... the best thing?

CATRIN: Yes it is.

SCOTT: Is that the best thing, to be / on your own

CATRIN: / Yeah it is though.

SCOTT: I could just, be with you, be there, not saying / anything –

CATRIN: / Yes it fucking is the best thing, for me to be on my own.
Alright?

BECKY: Shall I get you some chips and a piece of fish or a sausage or a Peters Pie or what?

MAGS: And it's happening now.
It's happening, again.

SCOTT: We used to go for chips every dinner time.

We'd cross Merthyr Mawr Road, then cut in the back of
the tennis club,
Then by the side of the river, into town.
There was a chip shop with a pool hall above.
It's a rock club now.
You may know it.
We'd bomb down there and wander back
Stopping on the bridge, sitting on the stones in Newbridge
Fields for a bit
With chip cones steaming off vinegar in our hands.
One day you said
D'you think you go on after you die?
Or is that just it, once you're gone you're gone?
You said, it'd be handy to know either way.
But so far no-one in history had figured it out.
And you said
Well then boys.
Looks like it's down to us.
We decided that whoever ghosted first should return and
Using our poltergeist powers turn off a light
On October the tenth, at ten o'clock precisely.
The tenth of the tenth at ten.
All the tens, you said.
Never gonna forget that, are we?
We spat in our hands and shook: I should Welly's hand,
Welly shook Rob's hand, Rob shook Huw McArthur's,
Huw McArthur shook yours, and then you shook mine.
And shaking spit round the gang
Sealed our oath –
That for the rest of our lives, on the tenth of the tenth, at
ten
We would all be looking out
For a message from the dead, in the dying of an electric
light.

And then we all had to finish our chips eating with the
wrong hands

Cos our right hands were covered in spit.

BECKY: Message twenty-nine of forty-five. No. Thanks.

MAGS: I would pray for disasters and every night
The news answered my prayers.
Have you seen this, love?

BECKY: What's that, mum?

MAGS: 'Glacier breaks off from Antarctic
Raising global warming fears'.

BECKY: You're not going to eat anything, then?

MAGS: Terrorism, floods, the collapse
Of the international financial system,
I lapped it all up. Because if my son lived
Seventeen good years and then died,
Just in time to miss the end of the world,
That would make sense.

SCOTT: And yeah
That first year
On the tenth of the tenth, at ten
I was on the look-out.
Course I told myself I was
Honouring him
Remembering him
I sat with every light in the house blazing and
Waited for my spit-brother to show.
None of us had said but I talked to Huw and Welly and
Rob after and
They'd all done the same.
My sister said
You'll get a message from him, in the end.
Course you will.

She said, if you wait enough years one of you
Will have a bulb go or a fuse blow
And maybe it won't happen at ten o'clock but at ten to,
But of that'll still count cos it was all about the tens.
You'll get your sign
If you want it enough to sit tight till it comes.

But I sort of think
I sort of thought
If a bulb went or a fuse blew
And it happened at exactly the right time
You were waiting for a sign –
- then that would be a sign. Wouldn't it?
Like if now, we say it's ten o'clock,
On the tenth of tenth –
I know it's not but if we pretend
- and if the lights go off right now,
At the very second we're pretending then
That would be a message. Right?

Like even if they go off cos
Someone trips on a wire or
Someone presses a wrong button.
That'd still be something.

Like even if they go off now
Cos someone listening switches them off deliberately
That would still be something, wouldn't it?
Like this light here.
If someone switched that light off now,

That would tell us something,
For definite.

BECKY: Message thirty-six of forty five. Sunday.

61

MAGS: The funeral... well at the funeral, you know what to do.
But then after...
You hear of people, when they lose someone
Keeping their rooms like they were?
So at first I do that.
But it just looks like a room no-one lives in:
Dust in drifts, dirty socks sitting on the floor,
A mug with an inch of coffee in the bottom, that dries up
And then furs up with mould and
Everytime I look at it
I can't help but think
What must be happening
To his beautiful body
Down there, in the ground...

BECKY: I'm gonna go put some flowers.
D'you wanna...
You feel like coming?

MAGS: I decide to just be normal.
Like things were still normal.
I charge in, pull back the curtains, push open the window
Gather up the socks and boxers and t-shirts and
I'm two steps from the washing machine and –

BECKY: You can't tell. Like mostly those first few months she was just
Very quiet, didn't get out of bed, didn't wash, didn't want to eat
But then one time I come home and found her
On the phone ordering these like... bags she'd seen on the telly,
Like JML vacuum bags and she was really hyper –

MAGS: They've got an airtight seal!

BECKY: Okay. I understand. What d'you need a bag
With an airtight seal for, mum?

MAGS: For this!

BECKY: She had this bin bag. Tied at the top.
 With all Lee's dirty clothes in.

MAGS: Now of course the bin bag's just
 A temporary measure, when we get these
 JML vacuum bags we'll be able to look at the clothes
 And keep them sealed so they won't lose –

BECKY: - the smell of him.

MAGS: And I was that close to washing them!

BECKY: So yeah some progress and then sometimes
 Right back to step zero.

SCOTT: It was the third year after he died, a message finally
 came through.
 There was a lamp on the table next to me and
 At ten o'clock precisely on the tenth of the tenth I realised
 The bulb was flickering. And it occurred to me if you could
 slow down time
 What looked like a flicker would actually be the light going
 off and on
 Just really quickly, like two thousand times a minute.

 And then I realised I didn't need to slow down time.
 Because I realised I could see quickly enough to count the
 flickers.
 I realised the flickers were a form of Morse code.
 I stared at the bulb for maybe two and a quarter hours
 Till I was sure I had the pattern of flickers right,
 Then I spent the rest of the night on the net, deciphering
 the message
 And what that flickering light bulb said was
 Mate: when you're gone
 You are fucking gone.

And that was me told.

BECKY: Message forty. Okay, you're forgiven, but I am gonna do some nasty stuff to you later
to make up for it, you sexy bitch. Kiss kiss kiss Lee.
Message forty-one. Mum. I think I just sent you a text for Cat. Really really really sorry.

CATRIN: I didn't leave town.
It's wasn't like a big thing, 'Catrin Leaves Town'.
I went to stay with my dad, and that
Was easier.
Cos here you had everybody putting on their sad faces
And watching what they say
And it's easier,
To not deal with that.
And of course I come home to see mum just
I don't go into town.
Don't really call anyone.
And that's easier. For me.

And soon enough people stop calling me, so
Seems like it's easier for them as well.

SCOTT: It is a bit embarrassing – you leave town
For the bright lights and big city,
And you get as far as... Cardiff.
But it's got a stadium, a castle,
A rift in the space-time continuum –
What more d'you want?

BECKY: I talked to one of these counsellors, CRUSE, for bereavement?
I told them what she was like and they said,
Yeah that's all normal. Which didn't fuckin' help.
And I said, so when's it gonna get better then, and
What they said was, you can't expect any improvement

For at least the first year.

I said, are you fucking kidding me?

They said, the first year, it's just reminders.

Like, the first Christmas without him. The first birthday.

The first summer...

MAGS: The first breath.

BECKY: All these really big markers.

MAGS: The first night. The first morning.

BECKY: And each one of them, you can't help but think, this is the first time we've done this,

Without the person who isn't there.

Which makes sense if you think about it.

MAGS: The first time you fill a kettle

For the first cup of tea.

The first time you put the rubbish out

And there's no volcano of crap spilling from his bin.

The first time a light bulb goes, and he's not there

To fetch down a spare from on top the cupboard.

The first time you get an official letter for him and have to phone them up.

The time you realise the letters for him

Have stopped.

The first time someone goes, how many kids've you got

And without thinking, you get the answer wrong.

The first time snow falls, and you think

How he still loves snow now, just like he did when he was a kid

And you hope he'll never lose that no matter how old he gets.

The first time you see the stars.

The first time you see the stars, on any particular night.

BECKY: Message forty-five of forty-five. Yeah will do see you
later.

MAGS: The first time someone goes, how many kids've you got
And you get the answer right.

BECKY: So I didn't expect her to get better, that first year.
And she didn't.

MAGS: The first time... you get a new phone.

BECKY: You could just copy them out.

MAGS: It's not the same.

BECKY: How's it not the same?

MAGS: I can't carry bits of paper round with me.

BECKY: Um... but obviously you can.

MAGS: I want them on my phone. So I can read them, on my
phone. I'm not sitting on the bus getting out bits of paper
like some / mad woman...

BECKY: / Alright, so... what do we do?

MAGS: I forward the messages to you. And then, when I've got
the new / phone...

BECKY: / Aren't they all on your sim anyway?

MAGS: Are you trying to finish me off?
Are you?

(Beat.)

When I've got the new phone, you send them back to me.

BECKY: I spend a night sending my mum
Forty-five text messages from my dead brother,
Her dead son.
There's a lot of that sort of thing.

MAGS: Thank you. Thank you, for being a help.

BECKY: Like afterwards they gave us his stuff back.
Stuff from the car?
He'd got it for two hundred quid from a bloke in Wildmill
And it broke down loads, so he always had like blankets,
A bottle of water, some of those little snack bars made out
Of seeds and nuts.
And tapes. Cos there was only a tape player, and a bust
radio.
And we didn't have any tapes but
Dad had left thousands of tapes behind
And in all those, a few alright ones.
We would pack loads of us in Lee's mini
He'd drive us to Southerndown, Monknash,

And we'd sing all these old songs, of dad's.

*BECKY sings 'Regret' by New Order – possibly with SCOTT and
CATRIN backing her up.*

Mikey, alone, echoes a line.

MIKEY: You used to be a stranger
Now you are mine...

SCOTT: And once I was in Cardiff I started going out.
I'd get so pissed I'd lose my friends, usually my phone,
very often my wallet,
Then pick my way home at dawn, navigating
By the spires of the stadium,
And it was fine.
But then this one time
I got jumped.
And the guy had a knife.
So I handed over my phone, my wallet.
Carried on walking along the embankment.
Then
Ran back after him,

Caught the fucker under the railway bridge and

He was maybe – fifteen? And he could not fucking believe it

When I came charging at him and then

Back at my flat

Chucking my shirt in the bin, I thought –

BECKY: No. No you're right.

I talk a lot about my mum.

Not much about Lee.

Funny that.

MIKEY: The conversation's tailing off, and I let it.

I let it die and she's still standing there, getting

A bit nervous, looking round, glancing at the bar

Glancing back to me then to the pub's wall-mounted plasma screen,

Suddenly transfixed by the subtitling on Sky Sports News.

I leave it oh till it hurts and then

I say to her

CATRIN: I start seeing this guy and

With most people, you'll wind round to a conversation

About history: who was your first, how did it go... how did it end?

There's none of that with this guy.

MIKEY: I say

What the fuck you doing still talking to me for?

CATRIN: He's a bit of a prick, to be honest.

MIKEY: Ninety-nine girls out a hundred

You hit them with a line like that,

And they're gonna run.

But you know what?

I've had ninety-nine girls out of a hundred,

Including your sister, your girlfriend and your mum,
And I am bored with them.
I'm well past it.
I want that one girl

Who you can look right in the eye, and say
What the fuck you doing still talking to me?
And she'll stand there, and take it.
Because that girl – will take anything.

CATRIN: Actually, he's a total prick.
And a prick is all I can handle, so – fair enough.

MIKEY: I am going to ruin you.
I am going to ruin you for all other men,
Because after you've had a night
Like we're gonna have tonight
You are never gonna be satisfied with
Any other fucker's limp-dicked effort again.

CATRIN: We get back to mine – and he's so pissed
He collapses. Spark out.

MIKEY: You might think talking the big talk
And delivering nothing makes me look a twat:
But actually, you're the twat.
You're the kind of bloke whose girlfriend I brutally shag
While you're off on some fucking stag do.
Because falling asleep on her toilet floor -
It's an assertion of dominance.
I am laying the groundwork for
Some pretty fucking avant-garde sexual experimentation.

CATRIN: I sort of change my mind and tell him I've got my
period,

And he says, but we could just cuddle, couldn't we?

MIKEY: One second you're all – I'm gonna put whatever I want

In whatever hole I want, and you're gonna love it.

Next second it's – can we have a little cuddle?

They never know what they're gonna get.

Keeps 'em on edge.

CATRIN: I lean in, kiss him, hard,

Bang my teeth on his lips and push my tongue

Right to the back of his mouth.

He staggers back, looks a little bewildered.

MIKEY: I wake up on the settee and there's a torn out page of Cosmopolitan

A biro scrawl says 'Where we are', and gives an address, a little map

Showing the nearest bus stop. And a phone number.

The phone number is crossed out. Next to it, the message, "Don't call."

Which means, do call.

So I don't.

So she calls me.

'Course she fuckin' does.

CATRIN: And one of those days things are rattling round my head

I call him and at the end of the night, the bouncers are circling, we

Shuffle off for the next place or maybe home and I realise

I've left my scarf behind, and the pub is locked up.

MIKEY: Now – *(Picks someone.)* you, in that situation,

You would probably say, oh I'll buy a new scarf for you,

And you'd think you were being a smooth fucker.

But you know what you are, actually?

You're a domestic contents insurance policy.

Boor-ring!

CATRIN: I hear him touch down in the beer garden, then
 Run inside the pub, bouncers shouting then –

MIKEY: Got it!

CATRIN: He scrambles back up the beer garden wall,
 My scarf streaming from his hand, and
 He jumps

MIKEY: A stunt like this, it's all about showing a girl
 You're not like anyone she's ever met before. You're
 spontaneous,
 Wild, uncontrollable. Time spent with you will always be
 an adventure.

CATRIN: He flips mid-air, and comes down – sideways.
 And screams.
 I'd never heard a man scream like that before.
 But apparently it really really hurts, when you break your
 pelvis.

MIKEY: I can tell you, it definitely, definitely does hurt, yeah.

MAGS: D'you know what the kids do to remember him?

BECKY: Halloween, we said we'd go out,
 In Lee's memory.

MAGS: They go on the piss.
 Obviously.

BECKY: We'd do it every year, we'd all come back
 On Halloween or the weekend after and meet in Jaggers,

 Which was Lee's favourite club,
 And it'd be like – a positive thing, you know?
 Celebrating his life, and
 Keeping his memory bright because
 If people still remember you, then

In a way, you're still alive.

SCOTT: And we do that, the first year,
And yeah it's great seeing everyone.

BECKY: Not everyone.

SCOTT: Catrin doesn't come.

BECKY: But other people do.
And it's not depressing or sad, we're all making it really positive.
Cos that's what Lee would've wanted.

SCOTT: But then Jaggers burns down.
So we get the message round, for the next year
Move the party up the hill to Bowlers but then
That closes down, and they knock it down,

BECKY: So then it's meet in the Roof cos even though Lee said
He hated the Roof he was there like three four times
A week from the time he was sixteen on and

SCOTT: It's the fifth year
When people start making excuses.

BECKY: Not excuses then. But like
Rhi's in Australia, Sarah's in Nottingham,
Steph's in Derby, Welly's in Aberdeen

– Geoff's in Los Angeles, for Christ's sake.
Louise is still there but she works in casualty at the Princess of Wales
And she's on shift that Saturday.
And then it seems like everyone else has got kids, and they
Might come out, but it depends on mums or sisters or babysitters.

SCOTT: Five years.
And every fucker forgets.

BECKY: They don't forget.

SCOTT: They don't forget
But the memory isn't enough
To move them, any more.

CATRIN: And first there are the paramedics, and the
ambulance,
Then the hospital, the doctors and nurses
And then – they send the prick home.

MIKEY: Jesus Christ, talk about disco damage.

CATRIN: So... give me a ring, you need anything?

MIKEY: What, are you –

CATRIN: What?

MIKEY: Are you going?

CATRIN shrugs.

MIKEY: Did you just – shrug?

CATRIN shrugs again.

MIKEY: I can't walk, I can't do anything and
You're just shrugging at me?

CATRIN: Did you want me to do something?

MIKEY: Yes!

CATRIN: Alright.
Say what it is, then.

MIKEY: I thought you were gonna
You know.

CATRIN: No I don't.

MIKEY: Look after me?

Beat.

CATRIN: Did you?

MIKEY: Well, duh.

CATRIN: And... why?

MIKEY: Because we're –
 You and me, we're –

CATRIN: It gets so that sometimes
 I go into the toilet and just pretend
 To be having a dump so I can take
 A few minutes away from him, and then
 I hear his voice
 I get to know the way he says my name

MIKEY: 'Cat-rin?'

CATRIN: With the 'rin' bit rising at the end.
 I know it and I hate it because
 It means another fucking thing
 He wants doing.

 And when I was little I remember thinking
 Love was this fluffy... cloud.
 This feeling
 Just being really happy all the time.
 But lying on that cold, damp, slimy bathroom floor
 Wanting nothing but to just be allowed to stop -
 There was this space inside me
 Something empty where all the lovely fluffy feelings
 Should be.
 And as the weeks went by I realised
 This empty place was filling up.
 There was something hard and heavy, in my guts.
 And that hard and heavy thing
 Would not let me walk away.

MIKEY: I lay on that settee
Felt all those hours in the gym working up
My biceps, my triceps, my quads
Going to nothing as my body turned pale and soft.
Nothing existed outside that lounge.
On telly I watched any live event I could find
- footy, show jumping, curling, even
The Pembrokeshire County Show and the Llangollen
International Eisteddfod, just to reassure myself
There was still a world out there.
And Catrin –

CATRIN: Oh, fuck...

MIKEY: - Cat?

CATRIN: Alright, alright...

MIKEY: Cat-rin?

CATRIN: Yes, what?

MIKEY: I was calling and calling.

CATRIN: Sorry, needed a dump.

MIKEY: Right.
Okay then.

CATRIN: It seemed like forever. Apparently it was only a
couple of months -

MIKEY: Okay. Let's do this.

CATRIN: And then he had to learn to walk again.

MIKEY: Fuck. Fuck. Fuckity fuck.

CATRIN: And obviously that hurt.

MIKEY: Bollocksy bollocking shit.

CATRIN: And I would watch him.

MIKEY: Bum balls willies tits poo!

CATRIN: In agony.

MIKEY: Can I stop?

CATRIN: Just do one more set.

MIKEY: The physio said, do them twice a day.

CATRIN: And?

MIKEY: That'll be ten times today, I do them again?

CATRIN: Don't you want to get better?

MIKEY: Course!

CATRIN: Well then...

MIKEY: Once I got my legs back, I wanted to use them.
 I went down the gym once or twice but it was just
 Lifting these blocks of metal up and down,
 I wanted to be out, looking around at everything
 Looking down at my legs, pushing me through the world
 Down streets, through parks –

 (To Catrin.)

 Made it to the barrage today.

CATRIN: Is it?

MIKEY: Am I babbling? I'm babbling a bit, aren't I?
 It's these fuckin' endorphins.

 He's just smiling at her.

CATRIN: What?

MIKEY: This is you.
 This is all you've done this.
 I don't just mean just my bones

CATRIN: Could you... give me a sec, yeah?

MIKEY: Cat?

CATRIN: Yeah just popping to the shop for milk...

MIKEY: And I thought that was a bit weird.
 And I then I heard her car door opening and I thought –
 She's obviously not going to the shop.
 I heard her car start.

MAGS: It's happening now.

MIKEY: I sat down.
 I thought well fair enough I see your point.

MAGS: It's happening again.

MIKEY: And then I was up, out the door
 And she was already at the end of the road
 Indicating left - I tear down there, bang on the window
 People coming out the shop looking at me like I'm fucking nuts
 She turns, her eyes are just

 (To CATRIN.)

 What? What?

 CATRIN looks at him; doesn't answer. MIKEY picks up his story.

MIKEY: Come back, please,
 Let's just talk about it. Can we? Cat?
 She looks away and pulls away and
 She's going. She's just gone.
 The road is a long and unwinding one and I can watch her
 For maybe half a mile, trundling away.
 Not even going fast. Not even rushing. Just
 Getting away from me.

BECKY: So you don't want nothing?

MAGS: No I'm fine thank you.

BECKY: Just not gonna eat nothing.
 Mum.

MAGS: Love, what?

BECKY: Look how thin you've gone.
 Look at the veins in your hands.

MAGS: What about them?

BECKY: They're all standing out.
 Look at me, look at my hands.
 You can't see veins.
 Look at yours.

MAGS: I've got to worry about my hands now as well, have I?

BECKY: I'm saying, it's cos of how thin you've gone.
 You're basically starving yourself.
 No wonder you feel like shit, when you're starving
 yourself.

MAGS: That's why, is it?
 That's why I feel shit.
 Because I'm not eating.
 I wish.

BECKY: Aw, / mum...

MAGS: / I wish it was that.

BECKY: And you do eat actually.
 I see the wrappers.
 Dairy Milk, Wagon Wheels, blocks
 Of that nasty cheese from the paper shop.
 You do eat.
 You must, or otherwise you'd be dead.
 So why pretend like you don't?

MAGS: My son.

BECKY: Yes.

MAGS: My son.

BECKY: I know.

MAGS: He doesn't eat.

BECKY: No.

MAGS: So how can I?

BECKY: Cos you must.

MAGS: How can I?

BECKY: Because you must.

MAGS: How can I?

BECKY: Because
 You want to.
 Because he died.
 But you want to live.

MAGS: No I bloody don't.

BECKY: But you must.
 You must do.
 I've seen the wrappers.

SCOTT: Some guy in a club tells me that people
 Are only really dead once they're forgotten.
 I think he was a Dr Who fan.
 But all the same I sort of know what he means and
 I try and keep Lee in my head. I try and have
 conversations with him
 And the thing is – it gets boring.
 I've got mates who've been twenty-five since before 9/11

 But Lee – is forever seventeen.
 He's got no opinion on any of the major world events
 Of the last few years. He thinks there will never be a black
 president

Except in all films. Has fuck all to say about the recession.

Doesn't even know what Facebook is.

And trickier still, he doesn't know me.

He still make lots of cock jokes.

And they would still make me laugh

Just I've fuckin' heard them all, so many times.

MIKEY sings 'Back When I Was 4', by Jeffrey Lewis.

BECKY: After A-levels I went on to art college, then a degree in fashion and knitwear design.

I was the first in my family of miners, steelworkers and barmaids

To sit A-levels, let alone go on to university.

Far as I know, I'm the last.

Mum cried when I graduated.

I hope it was cos she was proud.

Might well've been cos of Lee.

Cos he didn't graduate.

I got a job, assistant clothes designer, worked my way up and

After 5 years, I was head of design for... a company you'll've heard of.

Actually you'll've worn my stuff.

Actually... some of you still are.

I did that, and then –

I became mum to a lush, curly haired girl.

We called her Grace

I had to go back to work when Grace was 6 months for financial reasons and

I hated it.

I hated leaving Grace at nursery every day and the thought of having to leave her in clubs in the school holidays as well was the final straw.

The job I'd worked for and studied for and loved all those years – and now I hated it.

So after a lot of sums and a year of saving every penny I went back to university to retrain as a teacher.

Like I say, no-one in our family'd been so I thought might as well have a couple of goes.

That was 2 years ago and I am now in my first full year teaching technology and design.

Already it's like I've been doing it for years. School holidays doing fun stuff with Grace are great, and I haven't missed my old life as a clothes designer one single bit.

I found one career I loved so much – I can't believe I found two.

MAGS: I carry on.

 I carry on cos I can't find how to stop.

CATRIN: *(To MAGS.)*

 Mrs Davies I don't know if –

 Of course you remember me.

MAGS: I'm hardly likely to forget.

MIKEY: Come on, Mags, your turn...

BECKY: So if you're eating, why not eat with me, Mum?

MAGS: But then it's Becky.

BECKY: Just a couple of fucking chips...

MAGS: Becky,

 Typically bloody inconsiderate

 Goes and has a little girl. Grace.

 And she's –

 She hugs trees.

 Throws her arms round them, and kisses the bark.

 She loves animals. We take her to the petting zoo or if

 She sees a cat on the street, she'll stroke it and

 Some kids are rough, but she is so gentle.

 She comes round here and

She doesn't like the door closed
When she's on the toilet.
She likes it open so she can talk to me in the kitchen.
And I've got all these paintings and pictures of hers

Up on the side of the fridge.
And she was sitting there last week
Looking at them all, and she said to me,
Isn't it nice, Nan,
Seeing all those paintings I did
When I was just a little girl.
She's five.
She's five and so
The world can't end:
Not until she's finished with it.

SCOTT: I start volunteering for a charity
That's there to listen when people are in
Despair or distress. That's all we do,
Let people get things off their chest
When everything feels like too much.
This kid comes in one day.
He's pissed off about a lot of stuff.
And what often happens when someone's angry is
They take it out on the nearest person, and the nearest
person is me
And he says, what the fuck's wrong with you?
Who the fuck would be here, listening to a twat like me?
Why the fuck would you do that?
And I wonder, what it is, makes me do it.
What makes me get up, quarter to five in the morning,
Bike through the rain and wind

Put in three hours listening to sobbing strangers and the
occasional pervert,

And all before a full day at work.
What is it? What is it makes you do that?

BECKY: I was a bit impatient with her.
I think I had to be.
There are years when we don't speak much.
Cos I'm pissed off with her.
Then when Grace comes –
What the fuck are you doing?

MAGS: Nothing. Watching telly.

BECKY: You can't let her sleep like that!

MAGS: She was grizzling on her back, I put her on her front
And not a peep for hours.

BECKY: The risks of cot death
Are significantly raised when babies
Sleep on their front. Look on any website.

MAGS: You slept on your front. You were alright.
Actually they used to say, babies had to sleep on their front.

BECKY: They say different now.

MAGS: Because if they were sick in their sleep,
On their backs they could choke.

BECKY looks at her.

MAGS: I remember now the health visitor telling me.
Snidey little bitch...

BECKY: But Gracie sicks up loads...

MAGS: I know.

BECKY: So - she could choke.

MAGS: Put her on her front.

BECKY: But then it's cot death!

MAGS: Split the difference, pop her on her side?

BECKY: I'm just gonna have to watch her.

MAGS: All night?

BECKY: I'm just gonna have to sit up
And watch her
And make sure she keeps breathing
And make sure she doesn't choke.
That's obviously the answer.

MAGS: *(Beat.)*
I'll get you some coffee.

SCOTT: We get a house in the valleys, Alex and me.
We become valley commandos.
It's falling to bits, electric's buggered, chimney's caving.
But apparently Alex likes mending old neglected things.
I say, what – like me?

MAGS: Been nice seeing you.

CATRIN: And you.

MAGS: Don't leave it so long next time.

CATRIN: No.

MAGS: I mean I know why you did.
But don't.

CATRIN: I might be back
A bit more / now.

MAGS: / That'd be nice.
Because it helps, sometimes,
To remember the good things.

CATRIN: Yeah, of course.

MAGS: And you were the love of his life.

CATRIN: Mrs Davies,
 I don't think I was.

MAGS: Of course you were.
 Who else?
 No, you wouldn't have been.
 But as things stood: you were.
 You were what he got.
 Cos of you, he knew what it was like
 To be held, and hugged, and loved.

CATRIN: I wasn't –

MAGS: You weren't what, lovely?

CATRIN: You know it was my fault.

MAGS: It was an accident...

CATRIN: I did something horrible.
 I said horrible things.
 It was cos of me –

MAGS: No. Now – shut it.
 Just shut up.

 I know what happened that night.
 My son did something stupid and selfish and reckless
 He did the sort of stupid, selfish, reckless thing
 Teenagers do every day, and ninety-nine times out of a
 hundred,
 They get away with it.
 He didn't get away with it.
 He was that one time when it all goes to fuck.
 And that's not fair, it's not nice, but
 There's no reason why.
 It's just – the worst possible luck.
 And I can say all that.
 I can believe it, more or less.

But if you tell me.
If you say to me what happened.
If you put me there, in his head,
If you make me feel how bad he felt
And ask me to, what, forgive you for it?

SCOTT: I go into it quite realistic, thinking
There'll be good times and bad but
The truth is me and Alex never argue.
Just never do. He won't allow it.
Except this one time, when I tell the whole story
About Lee, and what a selfish twat he was.
And Alex says – right. And you're so hard on him
Because you think it's your fault?

I say sorry what the fuck?
Alex says of course you blame yourself. I know I would.
We argued that night.
For basically all of the night, in fact.

MIKEY: Back then.

CATRIN: Looks like.

MIKEY: Didn't have milk at the end of the road?

CATRIN: Just fancied a drive.

MIKEY: Right.

CATRIN: And then a trip home.

MIKEY: For a week.

CATRIN: Had a few people to catch up with.

MIKEY: Might've rung.

CATRIN: Left my charger behind.

MIKEY: Might've borrowed someone else's phone or used a
landline.

CATRIN: Don't know your number.

MIKEY: Might've emailed.

 Might've skyped.

 Might've poked me on Facebook to let me know you were alright.

 Ninety-seven per cent of first class mail reaches its destination by the

 following day so you could've sent me a postcard, if you liked.

 But you didn't.

CATRIN: That's just me. A free spirit.

MIKEY: Because once you take something like that,

 You let somebody drive off without a word

 And stay away as long as they like, well

 They've won.

 Cos they know, you'll take anything then.

 You just have to hope they came back

 Because of something good.

 And not because they're going to use you and torment you

 To try and work off some past unresolved hurt.

MAGS: Anyway I know what you did.

 You did the sort of stupid, selfish, reckless thing teenagers do every day.

 And ninety-nine times out of a hundred, they get away with it.

 Didn't you?

CATRIN: I suppose.

MAGS: So then

 Let yourself

 Get away with it.

SCOTT: I used to make up stories.

What Lee would have done.
Who he would have loved.
And I spent ages
They were so detailed, intricate,
Like an actual biography, pages and pages of typing.
Alex found them once and he
Cried. And he's not the type.
He said you should do something with these.
So I did.
I put them through the shredder with our bank statements.

CATRIN: Just another night of carnage in the Big End.
Good for a few hundred blurry photos on Facebook,
And hungover gossip in the morning.

SCOTT: He wasn't an angel, but he was an alright bloke.
But all anyone remembers now is that he died.
And
And I wish you could have met him.

MAGS: No, it never gets better.
That moment, when you realise he's gone,
It never goes. And it never gets easier.

CATRIN: And I'm alright.
I'm not amazing.
But I'm alright. I can say that.

BECKY: With Grace,
I start to see
What mum went through. Because
When you're young, all you know is, you're here.
You don't know what it means that someone carried you,
Felt you start to move inside them.
Maybe felt your foot poking into their belly,
Pushed gently at it, and felt you push back.
You don't know that when you came out
You couldn't even hold up your head.

Didn't even know how to suck.
So much goes into a kid –

But when you are a kid, you can't see it.
You don't remember the care it took to make you.
And so you're careless, with yourself.
And there are gonna be times when
You feel like you're worth nothing.
But the very fact you're here, feeling so bad
Means you're worth the world, to somebody.
And you've just got to fucking hold on to that.

MAGS: After the car crashed, and he lay there for two hours,
They say he was most likely unconscious.
I think he was awake.
I think he was looking at the stars.
I think he knew what he was losing.
The doctor said, he is a fighter,
He's not going anywhere, he's holding on,
But then he was saying to me
I'm so tired, mum.
And I said, well have forty winks then.
He said I can't, I'm scared.
What if I never wake up?
And I said
You sleep now, lovely.
You sleep now, if you want to.
He says you promise me?
He says you promise me I'll wake up again mum?

And I say
To my own son
Close them eyes, baby boy.
Mammy'll be here when you wake up.
And I still am.

I still am.

BECKY: She got better, in the end.
 You wouldn't see it day to day. You had to think back
 Remember how she was – a year ago, or six months.
 I'm going for chips – shall I get you some fish, as well?
 Mum?

MAGS: Ask them if it's haddock or cod;
 If it's haddock, alright, if it's cod – don't bother.

BECKY's looking at her, hugely relieved.

MAGS: What?

BECKY: Just... you're so fuckin' fussy.

MAGS: They say time is a healer,
 But they lie. Because time doesn't work after something
 like that.
 Time gets all jumbled up.
 Because that moment is never gone.
 It's happening now.
 It's happening – now.
 And it never gets easier,
 In my head, and my heart, it's still going on.
 What times does is

 It brings you other stuff.
 It brings you your daughter back.
 It brings you a grandchild.
 It brings you Grace.
 It brings you more love, that comes surging up inside
 Whether you can bear it or not.
 And sometimes you'd rather / lay down and

MIKEY: / Mags? It's your turn.

MAGS: Me?

BECKY: Go on...

MIKEY: Go on, sing for us.

CATRIN: Everyone else has had a go...

ALL: *(Chanting.)* Mags, Mags, Mags, Mags...

BECKY: *(As the chant continues.)*
It's your birthday, and you are singing
And that's the end of it.

MAGS: Alright, alright...

MAGS takes up the mike.

MIKEY: You ready?

MAGS: No.

MAGS sings 'A Fire In My Heart' by the Super Furry Animals.

BEFORE

Back to the very first scene: CATRIN and SCOTT, where we left them, outside the church.

SCOTT: And?

CATRIN: I dunno.

SCOTT: I just told you I love you and – you don't know?

CATRIN: Can I have like one second to think about it?

SCOTT: Course.

Just leave me hanging...

CATRIN: How d'you know you love me?

SCOTT: I think about you all the time, and I think you're amazing, and in case you hadn't noticed, I'm the one who chases after you when you strop off out the pub, so...

CATRIN: You are really easy to talk to.

Lot easier than Lee.

SCOTT: You know what we have to do?

We have to kiss.

And then how we feel in our bodies will tell us.

CATRIN: I can't, I can't, I can't, I'm with Lee, I can't –

(She stops.)

Oh, what the fuck...

She grabs SCOTT, and they kiss.

When they break –

SCOTT: Well?

CATRIN: I felt... a little bit giddy. A little bit out of breath. A little bit... like I couldn't believe I was actually kissing you.

SCOTT: Like you couldn't believe it was happening?

CATRIN: Yeah.

SCOTT: You couldn't believe it was happening to you?

CATRIN: But it is. Oh my God.

They look at each other.

CATRIN: I'm gonna have to tell Lee.

SCOTT: I know.

CATRIN: I can't believe it's really happening.
After all this time –
– love.

A snatch of the chorus of 'Regret' by New Order, sung by LEE and BECKY and CATRIN and SCOTT, in LEE's car on the way to Southerndown, years earlier.

And just as abruptly as it came in, the sound is gone.

Ends.